D1055486

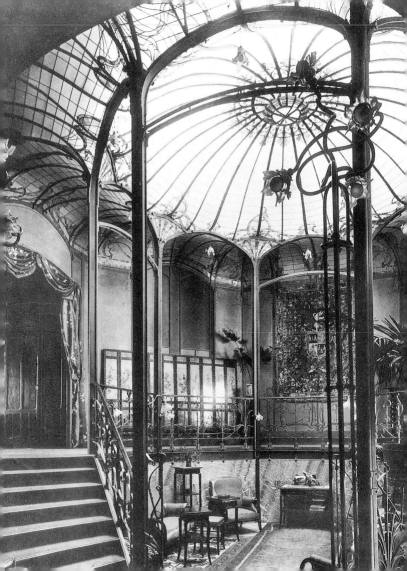

ART NOUVEAU

CONSTANCE M. GREIFF

ABBEVILLE
STYLEBOOKS™

ABBEVILLE PRESS · PUBLISHERS

NEW YORK · LONDON · PARIS

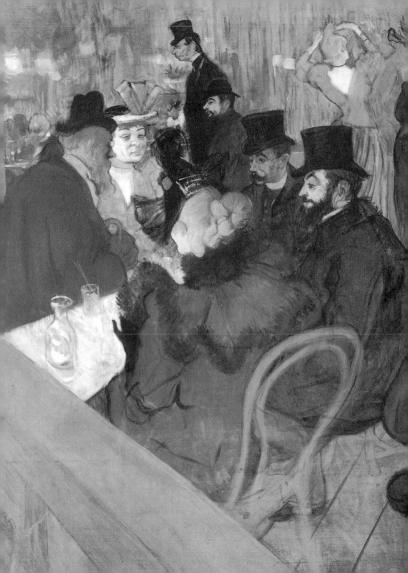

CONTENTS

INTRODUCTION

The new architecture needs new ornamentation.
The reflection and suppleness characteristic of the former
must also be features of the latter.

—Henry van de Velde, *Die Renaissance im modernen Kunstgewerbe*, 1901

Art Nouveau—the art of the new—flourished briefly from the mid-1880s through the first decade of the twentieth century, lingering in debased form until World War I. In its time it bore many names. Yachting Style, Stile Inglese, and Liberty Style (for the London department store) recognized its English roots. In Germany it was Jugendstil (the style of youth); in France, Le Style Moderne; in Spain, Modernista. Some terms were descriptive. Belgium called it Paling Stijl (eel style) and Style Nouille (noodle style). Eventually the accepted name came from Samuel Bing's Paris store, La Maison de l'Art Nouveau, which opened in 1895 and featured paintings, sculpture, glass, ceramics, and jewelry, all in the new style.

Art Nouveau's designers were conscious that they were creating a new movement in the arts. They repudiated past historicism, looking to the organic forms of nature for fresh inspiration. Banding into groups—the Century Guild and Arts and Crafts Exhibition Society in England, Les XX in Belgium, the Vienna Secession—they produced a spate of magazines and international exhibitions featuring their work. Totality of design was a guiding principle. Architects produced not only buildings but also interiors, furniture, wallpaper, and posters. Alphonse Mucha, now famous for his posters, also designed

jewelry; Emile Gallé produced furniture as well as glass. In Britain architects such as C.F.A. Voysey, Arthur Heygate Mackmurdo, and Charles Rennie Mackintosh, whose buildings belong to Arts and Crafts rather than Art Nouveau, designed wallpapers, furniture, textiles, and graphics with the characteristically sinuous, seductive line.

The patrons for Art Nouveau were also a new breed, made rich by the recent industrialization of western Europe and plunder from imperial holdings in Africa and Asia. The style's geographical focus reflected new wealth. With the exception of Paris, Art Nouveau architecture was centered not in the established world capitals but in cities such as Brussels, Barcelona, Nancy, Prague, Munich, and Turin.

Although accepted by the avant-garde, Art Nouveau never was a dominant style. Most clients still preferred classical or historical forms. Many designers who pioneered the style soon turned away from it toward a cooler, more geometric aesthetic that prefigured the modernism of the International Style. And time has not been kind to Art Nouveau buildings and interiors. Wars, fires, and changing tastes have taken a heavy toll. Even most of the stations of the Paris Métro—those hallmarks of Art Nouveau—have been destroyed. Only recently, with ornament's return to fashion, have the richness and seductive delight of the style become appreciated once more.

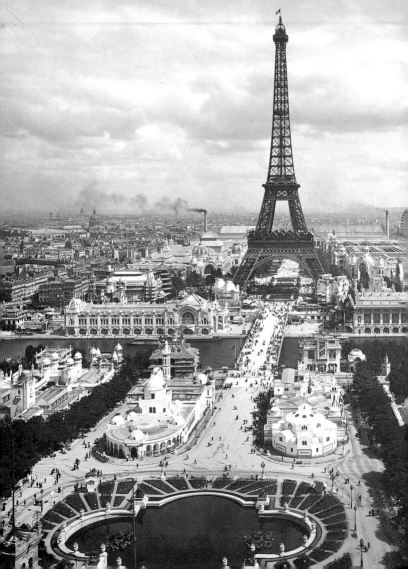

The end of an old era and the dawn of the new—for some it was time to cast off the conventions of the past and look forward to a bright future. Art Nouveau rejected historicism and revivals, celebrating instead the beauties of nature and the joys of the present. Yet for all its sunny colors and fresh forms, Art Nouveau also carried an undertone of melancholy, a whiff of decadence, a hint of unhealthy eroticism—the end of a civilization as well as a beginning.

Art Nouveau pavilions and displays at the 1900 Exposition Universelle spread below the Eiffel Tower, built for another world's fair a decade earlier.

9

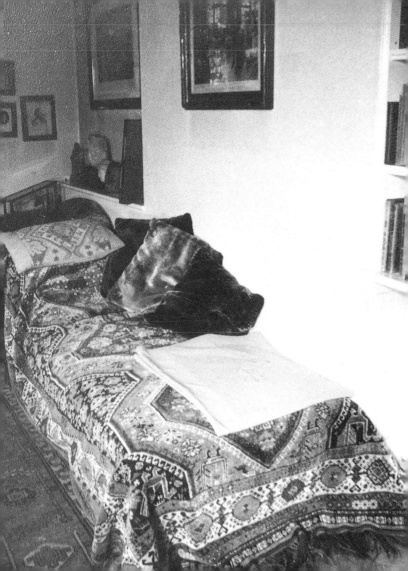

The period from 1880 to World War I was a time of unprecedented prosperity in Europe and the United States, despite interludes of economic depression. In the second half of the nineteenth century, industrialization spread from Great Britain across western Europe, bringing prosperity in its wake. The British Empire was at its zenith, and France, Germany, and Belgium had joined Britain as great imperial powers. Economic growth appeared to be unlimited.

A new spirit of freedom was in the air. Universal suffrage for men had been achieved in many countries, and the rights of women had been extended. Labor strife did exist, but unions were forming and gaining benefits and security for workers. Socialism was an accepted movement among many of the educated.

Yet society was showing strains, as each nation sought unlimited economic growth and political power. The arms race began in earnest in the 1880s. European powers rivaled one another for colonial possessions, world markets, and material resources. Amid the peace and prosperity of the *fin de siècle,* the seeds of discord that would culminate in World War I were being sown.

Sigmund Freud (1856–1939), who developed new ways of exploring the human psyche, shared his discoveries in *The Interpretation of Dreams* (1900).

The original psychoanalyst's couch was a prominent feature of Freud's study, decorously draped in an oriental carpet and strewn with pillows.

	1880	1882	1884	1886	1888	1890	1892	1894	1896	1898

POLITICS & SOCIETY

- Orient Express begins service ■
- London subway opens ■
- Economic depression affects Europe ■
- Leopold II of Belgium takes the Congo ■
- *Psychopathia Sexualis* (Krafft-Ebbing) ■
- Edison perfects incandescent light bulb ■
- First steel-framed building built in Chicago ■
- Automobile production begins in Germany ■
- Trans-Siberian Railroad started ■
- Diesel patents engine ■
- First automatic telephone switchboard introduced ■
- Henry Ford builds his first car ■
- World's Columbian Exposition held in Chicago ■
- Nobel Prizes established ■
- World's Fair held in Brussels ■
- Queen Victoria's Diamond Jubilee celebrated ■
- Dresden Exhibition held ■
- Curies discover radium ■

LITERATURE & PERFORMING ARTS

- ■ *Huckleberry Finn* (Twain)
- ■ *Symphony No. 3* (Brahms)
- ■ *The Mikado* (Gilbert and Sullivan)
- *A Study in Scarlet* (Doyle) ■
- Paderewski's debut ■
- *The Happy Prince* (Wilde) ■
- *Hedda Gabler* (Ibsen) ■
- *The Picture of Dorian Gray* (Wilde) ■
- ■ *The Light That Failed* (Kipling)
- ■ *Tess of the d'Urbervilles* (Hardy)
- ■ *Mrs. Warren's Profession* (Shaw)
- ■ *The Nutcracker* (Tchaikovsky)
- ■ *Trilby* (du Maurier)
- *The Time Machine* (Wells) ■
- First movies for paying audience ■
- *The Sea Gull* (Chekhov) ■

VISUAL ARTS & DESIGN

- Tiffany's patent for favrile glass ■
- Title page for *Wren's City Churches* (Mackmurdo) ■
- Gallé furniture ■
- Art Workers Guild ■
- Les XX (Brussels painters and sculptors) ■
- Liberty and Company Paris branch ■
- Toulouse-Lautrec's first posters ■
- Kelmscott Press ■
- *The Studio* magazine ■
- Tassel House (Horta) ■
- *The Cry* (Munch) ■
- Beardsley drawings for *Salomé* ■
- Munich exhibition of Obrist embroideries ■
- La Maison de l'Art Nouveau ■
- Eiffel Tower ■
- *Pan* magazine ■
- *Die Jugend* magazine ■
- Vienna Secession movement ■
- *Art et Décoration* magazine ■
- Majolica House (Wagner) ■
- Atelier Elvira (Endell) ■

	1880	1882	1884	1886	1888	1890	1892	1894	1896	1898

1900 1902 1904 1906 1908 1910 1912 1914 1916

- Boer War fought
- Exposition Universelle held in Paris
- *The Interpretation of Dreams* (Freud)
- Queen Victoria dies
- Marconi transmits radio messages
- Turin Exposition held
- Wright brothers make first powered flight
- Russo-Japanese War fought
- World's Fair held in St. Louis
- Einstein formulates Theory of Relativity
- First Ford Model T manufactured
- First flight made across English Channel
- Edward VII dies
- Revolution begins in China
- Lenin becomes editor of *Pravda*
- The *Titanic* sinks
- World War I begins

LITERATURE & PERFORMING ARTS

- *Ein Heldenleben* (Strauss)
- *Tosca* (Puccini)
- *Sister Carrie* (Dreiser)
- Ragtime jazz
- *Pelléas et Mélisande* (Debussy)
- *Man and Superman* (Shaw)
- *Peter Pan* (Barry)
- *The Golden Bowl* (James)
- First opera recording
- First radio transmission of music
- *The House of Mirth* (Wharton)
- *Salomé* (Strauss)
- *A Room with a View* (Forster)
- *The Firebird* (Stravinsky)
- Tango craze in Europe and U.S.
- *Daphnis and Chloé* (Ravel)
- Bernhardt stars in *Queen Elizabeth*
- *Remembrance of Things Past* (Proust)
- First Charlie Chaplin movies
- *Dubliners* (Joyce)

VISUAL ARTS & DESIGN

- Castel Béranger (Guimard)
- Artists' colony at Darmstadt
- Paris Métro (Guimard)
- Solvay House (Horta)
- Vienna Stadtbahn (Wagner)
- Buntes Theater (Endell)
- Interiors for Vienna School of Decorative Art (Hoffmann)
- Carson, Pirie, Scott Department Store (Sullivan)
- Willow Tearoom (Mackintosh)
- *Jungle with a Lion* (Rousseau)
- Casa Battló (Gaudí)
- First Cubist exhibition in Paris
- Casa Milá (Gaudí)
- *Birth of Venus* (Redon)
- Armory Show in New York
- *Death and Life* (Klimt)

1900 1902 1904 1906 1908 1910 1912 1914 1916

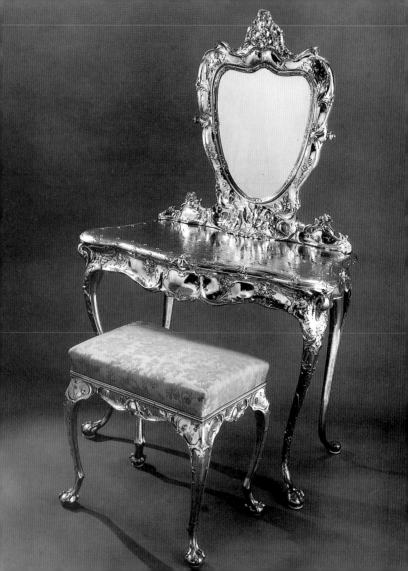

NOUVEAU RICHE

Art Nouveau patrons were beneficiaries of industrialization and colonialism. While the aristocracy and haute bourgeoisie clung to revivals, newly rich manufacturers, merchants, and former colonials embraced the new style. The Brussels architect Victor Horta designed the first full-blown Art Nouveau building, the Tassel House (1893), for the engineer who had laid out the Trans-Siberian Railroad; other clients included progressive lawyers and a manufacturing chemist. In Spain, Antoni Gaudí's patrons were second-generation merchants and industrialists, proponents of Catalan independence. Italian Art Nouveau took root in the rapidly industrializing north. Conservatism and long-established wealth may explain why English architects avoided Art Nouveau, although designers of decorative arts did not.

Newly affluent artists and entertainers were both inspiration and patrons for Art Nouveau. The actress Sarah Bernhardt commissioned posters by Alphonse Mucha for many productions and wore jewelry by Mucha and René Lalique. Architects such as Horta, Paul Hankar, Henry van de Velde, and Joseph Maria Olbrich designed their own homes in the Art Nouveau style.

This silver dressing table, "Matin et Soir" (1900, probably William Codman) made by Gorham and Company, was exhibited at the Paris Exposition.

Poet, playwright, and novelist, Oscar Wilde (1854–1900) captured the manners and morals of the *fin de siècle*.

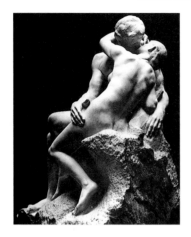

In Auguste Rodin's *The Kiss* (1886), the lovers with their intertwined limbs seem to grow organically from the block of rough marble.

In *The Cry* (1893), Edvard Munch used swirling curves to expose the fear underlying turn-of-the-century optimism.

Few artists worked exclusively in Art Nouveau, but many felt its influence. In the late 1880s, before moving in other directions, Paul Gauguin, at Pont-Aven, worked with planar surfaces, heavy curving lines, and flat colors. French sculptors such as Aristide Maillol and Auguste Rodin briefly explored Art Nouveau themes.

The Norwegian painter Edvard Munch used Art Nouveau's flowing curves to express eroticism and horror. Vienna's Gustav Klimt combined sensuous linearity with abstract, jewel-like patterns. Also known for their Art Nouveau work are the Dutch painters Johan Thom Prikker and Jan Toorop and the Belgian sculptor Georges Minne.

The line between fine and applied arts was blurred. Henri de Toulouse-Lautrec and Pierre Bonnard, as painters, were late Impressionists, but their posters are unabashedly Art Nouveau. Designers such as Henry van de Velde and Louis Majorelle were trained as painters, while Hermann Obrist, remembered for his embroideries, was a sculptor.

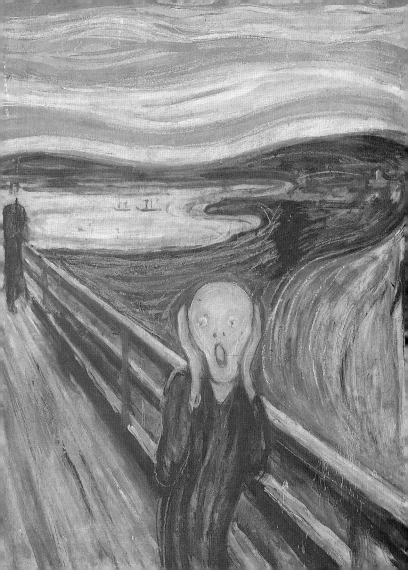

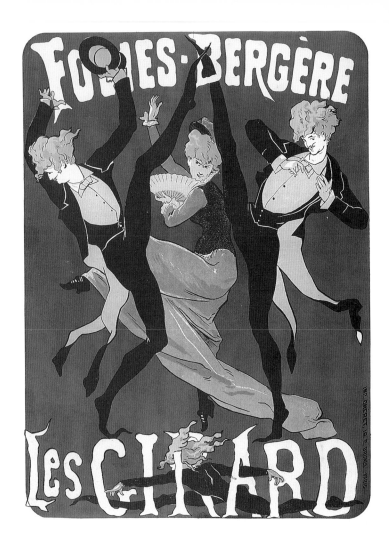

COME TO THE CABARET

The lure of "Gay Paree" at the turn of the century—the wonderful and somewhat wicked world of the Moulin Rouge and the Folies Bergères—was captured in posters advertising the city's nightlife. Designed by Alphonse Mucha, Pierre Bonnard, Jules Chéret, and, above all, Henri de Toulouse-Lautrec, these posters promoted and, in the process, immortalized the artistes of Paris. Many of them, including Jane Avril and May Milton, were English. The American dancer Loïe Fuller was an especially popular subject. Her dances, in which she manipulated diaphanous cloths on long sticks under moving, varicolored spotlights, were Art Nouveau brought to life. She inspired not only paintings and posters but also numerous statuettes.

Art Nouveau designers also created posters to promote their publications and frequent exhibitions, as well as everything from bicycles to cigarettes to salad oil. In the United States Will Bradley designed expressive posters that were strongly influenced by Aubrey Beardsley.

Jules Chéret's poster for the Folies Bergères (1877) was one of the first to capture in Art Nouveau style the excitement of the dance.

The English dancer Jane Avril was the subject of several posters by Henri de Toulouse-Lautrec, including this 1893 one.

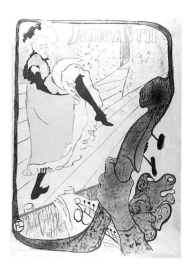

ARABELLA AND
ARAMINTA STO-
RIES BY GERTRV-
DE SMITH WITH
XV PICTVRES BY
ETHEL REED

BOSTON COPE
LAND AND DAY
PRICE $2.00 NET

Ethel Reed's 1895 poster (above) and Will Bradley's cover for *The Chap-Book* (opposite) typified Art Nouveau.

Art Nouveau Journals

The Studio (1893), London

Pan (1895), Berlin

Jugend (1896), Munich

Art et Décoration (1897), Paris

Ver Sacrum (1898), Vienna

Although many of its artists and patrons espoused socialist principles, Art Nouveau actually was a style for the elite: its individualistic designs carried a high price tag. The audience was both well-to-do and well educated, so publications became an excellent method for disseminating the style. Magazines and books proved to be an ideal medium for design unity, a principle central to the Art Nouveau aesthetic. Just as in an ideal building a single designer was responsible for architecture, interiors, and furnishings, the ideal publication was unified in design, typography, and illustrations.

In the 1890s designers themselves sponsored journals showcasing the Art Nouveau style. More conventional magazines, such as *Harper's Bazar* and *Century Magazine*, commissioned covers from Will Bradley, Maxfield Parrish, and Eugène Grasset.

Art Nouveau book designs abounded. Some of the most beautiful came from the Kelmscott Press, founded by William Morris in 1891, but established publishers also employed illustrators such as Walter Crane, Aubrey Beardsley, and Charles Ricketts. Lavish embossed cloth or leather bindings offered a preview of delights within.

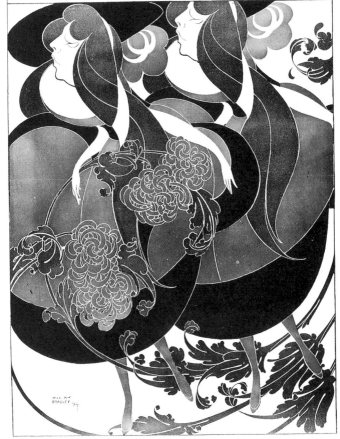

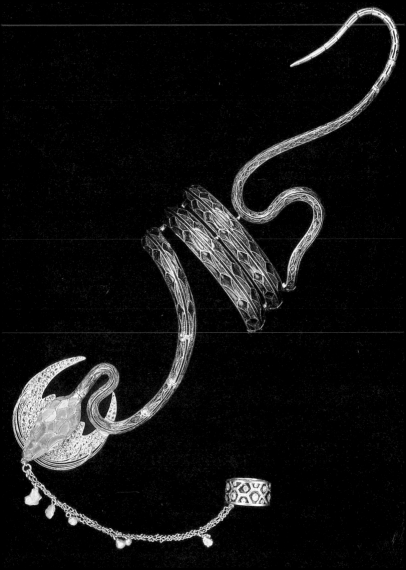

A few women wore unbelted, flowing gowns with Art Nouveau embroidery, but the chief fashion expression of the style was in jewelry. The most exquisite designs came from the workshops of René Lalique, who would later switch to the production of glass. Other major Paris jewelers were Eugène Feuillâtre, Georges Fouquet (for whom Alphonse Mucha designed), and Henri Vever; Eugène Grasset among others worked for Maison Vever. In Brussels, Philippe Wolfers frequently used ivory from the Congo, a material that would gain even greater popularity in Art Deco.

Art Nouveau jewelers made free and unusual combinations of materials. Gold and silver formed settings for precious and semi-precious gems—luminous, shimmering stones such as opals, pearls, and moonstones were preferred. These mingled with less conventional materials, from enamel to glass, ivory, and horn. Popular jewelry forms were brooches, pendants, and back combs.

In the early twentieth century American firms such as Unger Brothers of Newark, New Jersey, mass-produced silver Art Nouveau jewelry. Although graceful, their designs lacked the refinement and originality of the work of the great European jewelers.

Popular Animal Forms in Jewelry

Butterflies

Swallows

Dragonflies

Bees

Grasshoppers

Georges Fouquet's magnificent gold serpent bracelet, set with opals, emeralds, rubies, and diamonds, was made for the actress Sarah Bernhardt in 1899.

LIBERTY STYLE

Art Nouveau was above all a decorative style. Its curving forms and ornament derived from nature appeared in all types of goods as well as buildings. A powerful force in conveying the new style was the line of wallpapers, textiles, metalwork, and furnishings produced for Liberty and Company of London. In cities such as Paris and Brussels this Liberty Style, under various names, was everywhere—in posters, publications, shop fronts, and cafes.

Gustav Klimt designed shimmering, intricate mosaics for what was a severe dining room in the Palais Stoclet (1905–11, Josef Hoffmann), Brussels.

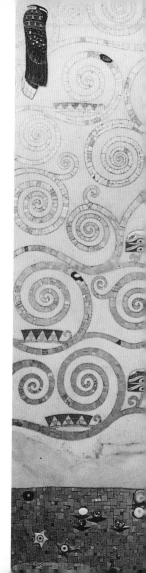

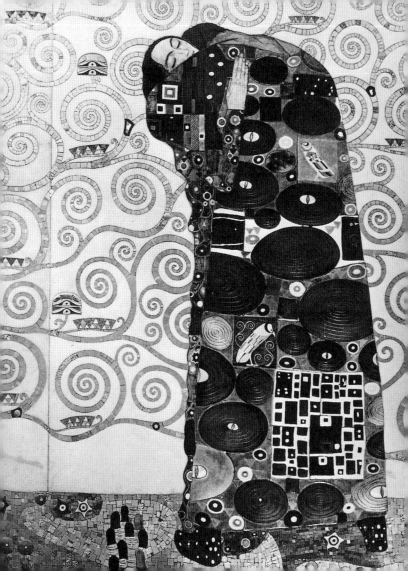

THE DOMINANT LINE

Although plastic
and sculptural, the
swooping form is
also a paean to line in
the staircase of the
Stepan Riabushinsky
House (1902, Fyodor
Shekhtel), Moscow.

The otherwise stark
facade of the Atelier
Elvira (1898, August
Endell), Munich,
was enlivened by the
fantastic forms of
applied ornament and
window mullions
(pages 28–29).

*Line is all-important.
Let the designer,
therefore, in the
adaptation of his
art, lean upon the
staff of line. . . .*
—Walter Crane,
*Transactions of the Art
Congress,* 1889

The chief expressive mode of Art Nouveau was line—sinuous, sensuous, serpentine, turning back on itself like a whiplash. Whether in embroidery (Hermann Obrist), wallpapers and textiles (Arthur Heygate Mackmurdo and C.F.A. Voysey), or graphics (Walter Crane and Aubrey Beardsley), line defined fluid, attenuated forms, played over surfaces, and created abstract patterns. Movement and the interplay of flowing organic motifs gave Art Nouveau designs the quality of vivid life, linking art to nature.

Even in three-dimensional works, line was dominant. It whipped through or swirled around glass vases, outlined the fields of stained-glass windows and lamp shades, and was applied over or engraved into the surfaces of metal and ceramics.

In architecture the facades and rooflines of buildings could be made to appear as undulant line, as Antoni Gaudí did in his Barcelona works, including Casa Milá (1910) and the Sagrada Familia (1883–). Or line could enliven essentially flat surfaces, as in the series of tearooms Charles Rennie Mackintosh designed for Miss Cranston in Glasgow at the turn of the century or Otto Wagner's Majolica House (1898) in Vienna.

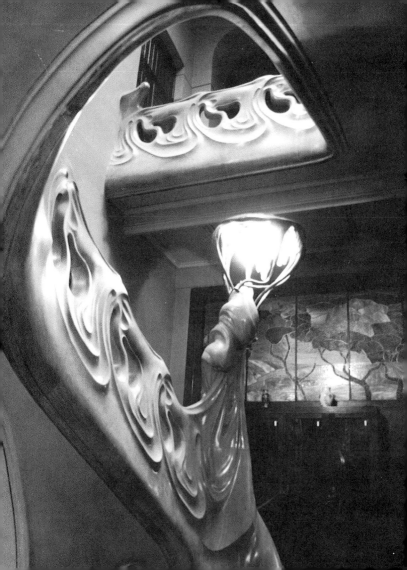

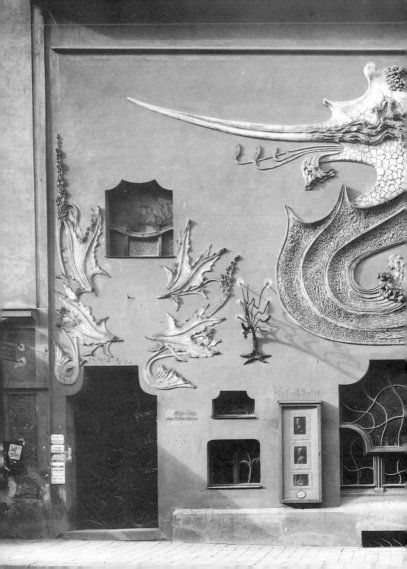

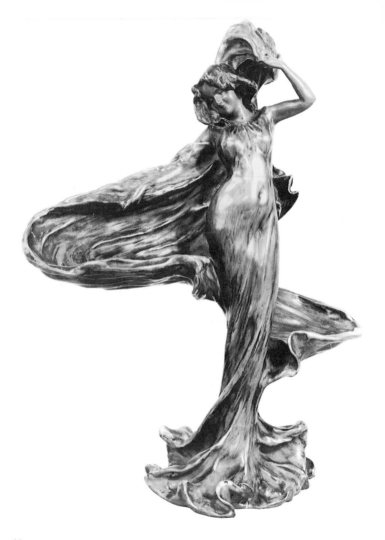

The motifs of Art Nouveau were varied, but most derived from organic, natural forms rather than geometric abstractions. Foliage and flowers of all kinds ran riot through everything from jewelry to building facades; designers were particularly fond of those with dramatic form such as lilies, irises, and orchids.

Insects also appeared frequently, especially in jewelry. Designers exploited the dramatic contrast between their opaque bodies and translucent wings. With the taste for the macabre that often lurked beneath Art Nouveau's surface, serpents, spiders, and octopuses often slithered across decorative objects.

Movement and flight were admired, so birds, especially swallows and herons, also became part of the repertoire. A favorite motif was the peacock and its plumage.

Slender maidens, nude or in fluid draperies but always with long, flowing hair, were ubiquitous in jewelry, statuettes, graphics, candlesticks, and a host of small, decorative articles.

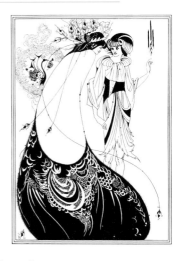

Aubrey Beardsley combined several Art Nouveau motifs in "The Peacock Skirt," illustrating Oscar Wilde's *Salomé* (1894).

Loïe Fuller inspired statuettes in metal, glass, and ceramics, such as this earthenware one (ca. 1900, Reissner Stellmacher Kessler).

ART NOUVEAU FEATURES

Siting: Usually urban, with plans conforming to city lots; minimal setbacks or landscaping.

Facades: Frequently asymmetrical. Undulant, plastic with projections and recesses, or flat.

Roofs: Conforming to local tradition: mansards in Paris; steep and chateauesque in Nancy; flat or gabled in Brussels; irregular and individualistic in Barcelona.

Materials and colors: Brick, stone, and stucco in natural palettes, often combined for contrasts in color and texture; ceramics, iron, and glass used for ornament. Also jewel tones and pastels, overlaid in paint, ceramic tile, or glass.

Doors: Prominent; often off-center with rich, curvilinear ornament. Elaborate iron gates.

Windows: Either rectangular and regularly spaced or irregular and arched in various forms, including reverse curves. Large expanses of glass in shops and department stores. Stained glass.

Balconies: Sometimes extending across facade; small window balconettes.

Ornament: Floral or animal motifs; murals, ceramics, or applied stucco; shop names in Art Nouveau lettering.

Antoni Gaudí's Casa Milá (1910) is considered one of Art Nouveau's masterpieces.

Ornamental towers and chimneys

Urban site

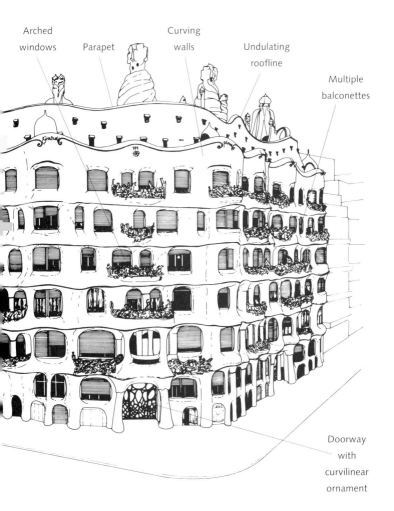

Arched
windows

Parapet

Curving
walls

Undulating
roofline

Multiple
balconettes

Doorway
with
curvilinear
ornament

ORGANIC ROOTS

Our roots are in the depths of the woods, beside the springs, among the mosses.
—Inscription above the door of Emile Gallé's studio

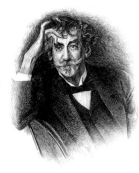

The American expatriate painter James McNeill Whistler (above) used forms and colors in his Peacock Room (1877) for the Leyland residence in London (opposite) that significantly influenced Art Nouveau.

The late-nineteenth-century stylistic movements that revolted against historicism nevertheless were influenced by the past. Both Art Nouveau and Arts and Crafts found inspiration in the writings of John Ruskin, William Morris, and Eugène Viollet-le-Duc, who espoused a return to the organic forms found in Gothic art and architecture. In England these ideals were given visual form by Morris and his followers and by the Pre-Raphaelite painters, who were also influenced by William Blake, the mystical, early-nineteenth-century watercolorist.

Japanese porcelains, textiles, and prints were powerful influences. Samuel Bing and Arthur Lasenby Liberty had started as purveyors of orientalia before repositioning themselves as promoters of Art Nouveau wares. Japanese references abounded in the work of the American painter James McNeill Whistler long before his proto–Art Nouveau design for the Peacock Room (1877).

Another strain in English Art Nouveau and in the work of Louis Sullivan was Celtic decoration, with its intricate patterns of interlacing motifs. French and German Art Nouveau were influenced by the graceful curves and scrolls of the Rococo style.

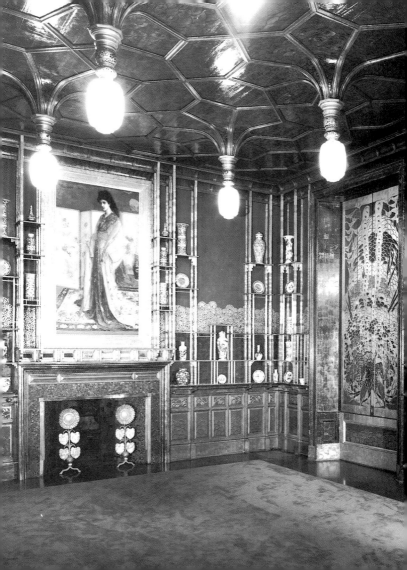

ARCHITECTS

Emile André (1871–1933)
92, bis quai Claude-le-Lorrain
(1903), Nancy, France

Peter Behrens (1868–1940)
Behrens House (1901),
Darmstadt, Germany

**Bědrich Bendelmayer
(1871–1932)**
Central Hotel (1902, with
Dryak and Ohmann), Prague;
Grand Hotel Europa (1907),
Prague

**Francesc Berenguer I Mestres
(1866–1914)**
Gaudí House (1904), Barcelona

René Binet (1866–1911)
Porte de la Concorde, Paris
Exposition (1900);
Grands Magasins du Printemps
(interior) (1907), Paris

Ernest Blérot (1870–1957)
Townhouses, Saint-Boniface
area, Brussels

**Raimondo D'Aronco
(1857–1932)**
Turin Exposition (1902)

**Lluis Domenech I Montaner
(1850–1923)**
Palau de la Musica Catalana
(1908), Barcelona

August Endell (1871–1925)
Atelier Elvira (1898), Munich;
Buntes Theater (1901), Berlin

Pietro Fenoglio (1867–1927)
Villa Scott (1902), Turin, Italy

**Antoni Gaudí y Cornet
(1852–1926)**
Sagrada Familia (1883–),
Barcelona;
Casa Calvet (1898), Barcelona;
Palau Güell (1900), Barcelona;
Casa Battló (remodeling)
(1906), Barcelona;
Casa Milá (1910), Barcelona;
Park Güell (1914), Barcelona

Hector Guimard (1867–1942)
Castel Béranger (1899), Paris;
Métro (1900–13), Paris;
Synagogue, rue Pavée (1913),
Paris

Paul Hankar (1861–1901)
Hankar House (1893), Brussels

Josef Hoffmann (1870–1956)
Apollo Candle Shop (1900),
Vienna

Victor Horta (1861–1947)
Tassel House (1893), Brussels;
Solvay House (1898), Brussels;
Horta House (1898), Brussels;
Maison du Peuple (1899),
Brussels

Frantz Jourdain (1859–1945)
Grands Magasins de la
Samaritaine (1891–1914), Paris

Jan Kotera (1871–1923)
Peterka House (1900), Prague

**Jules Aimé Lavirotte
(1864–1924)**
12, rue Sédillot (1899), Paris;
2, avenue Rapp (1902), Paris

**Charles Rennie Mackintosh
(1868–1928)**
Tearooms for Miss Cranston
(1897–1904), Glasgow

Bědrich Ohmann (1858–1927)
Cafe Corso (1898), Prague

**Joseph Maria Olbrich
(1867–1908)**
Secession House (1898),
Vienna;
Artists' colony (1899–1908),
Darmstadt, Germany

Charles Plumet (1861–1928)
50, avenue Victor Hugo
(ca. 1900) , Paris

Paul Saintenoy (1862–1952)
Grands Magasins Old England
(1899), Brussels

**Louis Henri Sullivan
(1856–1924)**
Carson, Pirie, Scott Department
Store (1903), Chicago

Eugène Vallin (1856–1922?)
22, rue de la Commanderie
(1902), Nancy, France

**Henry van de Velde
(1863–1957)**
Havana Company Cigar Shop
(1900), Berlin;
Various interiors and
furnishings

Otto Wagner (1841–1918)
Majolica House (1898), Vienna;
Stadtbahn stations (1900),
Vienna

**Lucien Weissenburger
(1860–1929)**
24, rue Lionnois (1904), Nancy,
France;
Hôtel-Brasserie Excelsior (1910,
with Alexandre Mienville),
Nancy, France

DESIGNERS & ARTISANS

C. R. Ashbee (1863–1942)
Jewelry, metalwork

Edouard Colonna (1862–1948)
Interiors, furniture

Auguste and Antonin Daum
Glass

Eugène Feuillâtre (1870–1916)
Jewelry

Georges de Feure (1868–1928)
Furniture

Eugène Gaillard (1862–1933)
Furniture, metalwork

Emile Gallé (1846–1904)
Glass, furniture

René Lalique (1860–1945)
Jewelry, glass

Margaret Macdonald Mackintosh (1864–1928)
Metalwork, stained glass, embroidery

Arthur Heygate Mackmurdo (1851–1942)
Furniture, textiles, wallpaper

Frances Macdonald McNair (1873–1921)
Furniture, stained glass

Louis Majorelle (1859–1926)
Interiors, furniture

Hermann Obrist (1863–1927)
Textiles, embroidery

Bernhard Pankok (1872–1943)
Furniture

Richard Riemerschmid (1868–1957)
Interiors, furniture

M. H. Baillie Scott (1865–1945)
Furniture

Tony Selmersheim (1871–?)
Interiors, furniture

Gustave Serrurier-Bovy (1858–1910)
Interiors, furniture

Louis Comfort Tiffany (1848–1933)
Glass, lamps, jewelry

Henri Vever (1854–1942)
Jewelry

C.F.A. Voysey (1857–1941)
Wallpaper, textiles

Philippe Wolfers (1858–1929)
Jewelry

ILLUSTRATORS

Aubrey V. Beardsley (1872–98)
Book illustrations

Will H. Bradley (1868–1962)
Posters, book illustrations

Jules Chéret (1836–1930)
Posters

Walter Crane (1845–1915)
Book illustrations, ceramics

Eugène Grasset (ca. 1840–1917)
Book illustrations

Alphonse Mucha (1880–1939)
Posters, jewelry

Maxfield Parrish (1870–1966)
Posters, book illustrations

Henri de Toulouse-Lautrec (1864–1901)
Lithographs, posters

ARTISTS & SCULPTORS

Paul Gauguin (1848–1903)
Paintings

Gustav Klimt (1862–1918)
Paintings, mosaics

Aristide Maillol (1861–1944)
Sculpture

Georges Minne (1866–1941)
Sculpture

Edvard Munch (1862–1944)
Paintings

Johan Thom Prikker (1868–1932)
Paintings

Odilon Redon (1840–1916)
Paintings

Auguste Rodin (1840–1917)
Sculpture

Jan Toorop (1858–1928)
Paintings

James McNeill Whistler (1834–1903)
Paintings, Peacock Room

Whether intended for an apartment house, private residence, department store, shop front, or cafe, Art Nouveau exterior designs were highly individualistic. Sometimes they featured surprising combinations of materials, colors, and textures. This variety, along with curvilinear shapes and flowing forms, created buildings full of excitement and life. Lavish ornament, often floral, re-placed landscaping and promised interiors full of seductive delights.

Ceramic tiles in bright, pastel colors form wreaths across the facade of Majolica House (1898, Otto Wagner), an apartment building in Vienna.

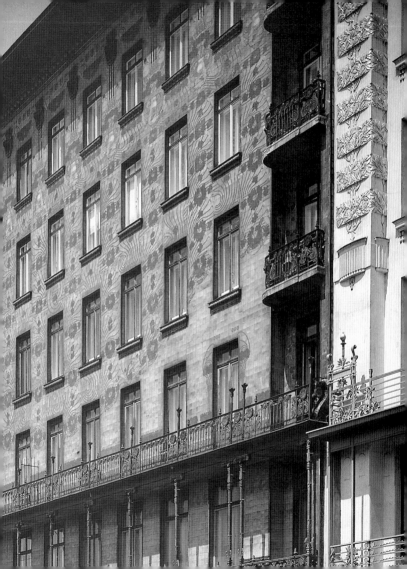

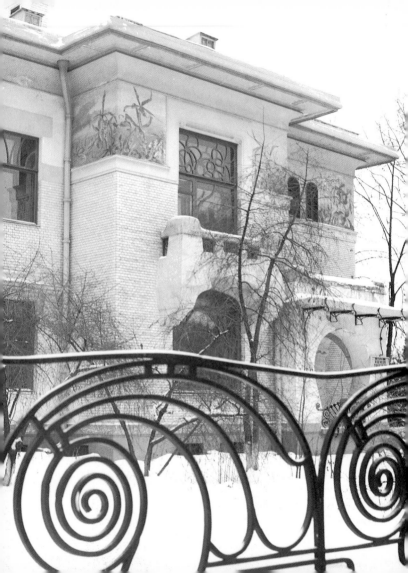

MATERIALS AND COLORS

The basic building materials of Art Nouveau were surprisingly conventional. Stone, brick, and stucco predominated, although these were often worked or combined to provide contrasts of texture and color. Even the undulating contours of Antoni Gaudí's Casa Milá (1910), which look as if they were poured concrete, are actually hammered stone.

Iron was a favored material, used both structurally and ornamentally. Usually wrought iron was preferred because it could be readily manipulated into the whiplash curves that characterized Art Nouveau. But for the Paris Métro stations Hector Guimard used cast iron, formed into skeletal and floral shapes and masks and combined with wrought iron and translucent webs of glass.

Colored glass and ceramics in pale pastels or bolder tones provided surface patterning and accents. Polychrome ceramic tile was used to accent openings and form friezes. At Majolica House (1898, Otto Wagner) in Vienna, the entire facade of an otherwise restrained, rationalist building is covered entirely by ceramic tile in a swooping floral pattern, while Gaudí studded walls and roofs of his idiosyncratic structures with mosaics of broken tile and plaques of tinted glass.

Fyodor Shekhtel's house for the art collector and merchant Stepan Riabushinsky (1902) established Moscow as the easternmost bastion of Art Nouveau. The materials combined polished brick with a deep mosaic frieze and iron railings.

Ceramic Mosaics on Art Nouveau Houses

House in calle Llansá (ca. 1900, anonymous), Barcelona

Olbrich House (1901, Joseph Maria Olbrich), Darmstadt

Villa in viale Michelangelo (1904, Giovanni Michelazzi), Florence

Galimberti House (1905, Bossi), Milan

DOORS AND WINDOWS

The great curves of the doorway and stair window, broken further by the springing line of the iron ornament, make an exciting composition on the facade of this artist's studio (ca. 1900, Ernest de Lune) in the Ixelles section of Brussels.

Art Nouveau doors and windows both came in conventional rectangular shapes, but frequently they were arched. No single shape characterized the Art Nouveau arch, which might be round, pointed, parabolic, or Moorish or given the reverse curve typical of the style. Openings frequently were further divided into curvilinear shapes by mullions of stone or iron.

Often placed off center, entrances were prominent architectural features. A favored treatment was to surround them with stone carved in organic forms and shielded by elaborate wrought-iron grilles or gates.

Art Nouveau windows defy categorization. Rectangular windows sometimes were ranked in rows; windows of several shapes and sizes also appeared in a single building. Bay and recessed windows helped achieve an undulating, plastic look for the facade.

For department stores and shops or in Victor Horta's destroyed Maison du Peuple (1899), windows might take the place of the wall—great expanses of glass held in place by narrow iron elements. Stained glass also gave emphasis to major windows, becoming a decorative element for both the exterior and the interior.

OUTSIDE

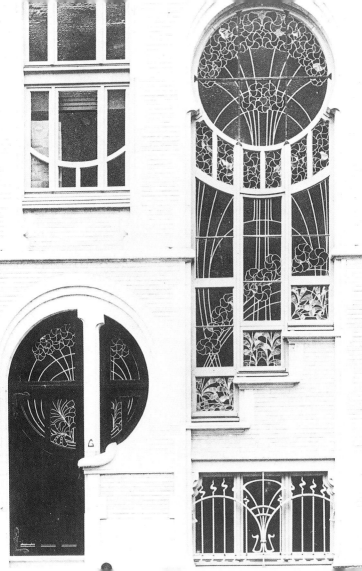

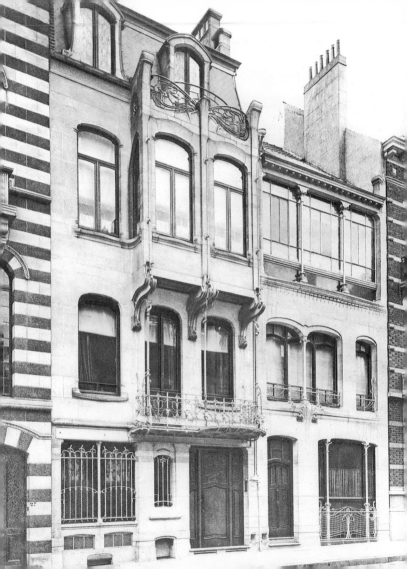

ROOFS AND BALCONIES

When it came to rooflines, many Art Nouveau architects bowed to local tradition. In Paris the mansard roof prevailed. In Nancy roofs were high, steeply pitched, and concave, following the Franco-Flemish medieval tradition. Houses in Brussels by Victor Horta and other architects appear from the street to have flat or gabled roofs, but their rooflines often are quite complex. To provide light to the interior of deep, narrow houses with shared walls, Horta designed great interior stairhalls. These rose from the ground floor to the roof, where they were crowned with skylighted domes.

Antoni Gaudí's rooflines are unique. Rearing like great natural upheavals—an earthquake or a tidal wave—they incorporate chimneys and towers in fantastic shapes.

No Art Nouveau motif was more ubiquitous than the balcony. In some buildings balconies stretched across the entire facade at one or more levels. More frequently, they fronted individual windows. Some were straight; others bowed outward. Railings might be of carved stone, but the usual material was wrought iron formed into curving botanical or organic forms or into the sinuous Art Nouveau whiplash.

Balconied Buildings

Solvay House (1898, Victor Horta), Brussels

Maison Cailliot (1900, Hector Guimard), Lille

24, rue Lionnois (1904, Lucien Weisenburger), Nancy

Villa Ruggeri (1907, Giuseppe Brega), Pesaro

Delicate ironwork fronts most of the windows and adorns the roof of Victor Horta's house and studio (1898, Brussels, now the Horta Museum.

Sullivanesque foliate forms adorn this door of the Madlener House (1902, Richard E. Schmidt), Chicago.

Hector Guimard's lighting fixtures for the Paris Métro resemble flowers but are unlike any that ever grew.

Ornament could be an intrinsic element in Art Nouveau architecture or applied, like the stucco spiraling across the Villa Ruggeri (1907, Giuseppe Brega) in Pesaro. Whichever the case, it usually was curvilinear, based on the Art Nouveau line that spiraled and twisted, as if delineating the contours of some exotic organism.

Peacocks, serpents, and maidens appeared on the exteriors of Art Nouveau buildings. A gigantic statue of Loïe Fuller fronted her pavilion at the 1900 Paris Exposition. Alphonse Mucha's design for Georges Fouquet's jewelry shop featured a frieze of female heads and a relief of a woman in a diaphanous gown rising the height of the shop front.

But by far the most common type of ornament was based on botanical forms. These could be realistic, abstract, or invented. Garlands of relatively realistic foliage ran across the balconies of the Grands Magasins de la Samaritaine (1907, Frantz Jourdain), Paris, while the flower frieze of the Karlsplatz Stadtbahn station (1900, Otto Wagner), Vienna, is highly stylized.

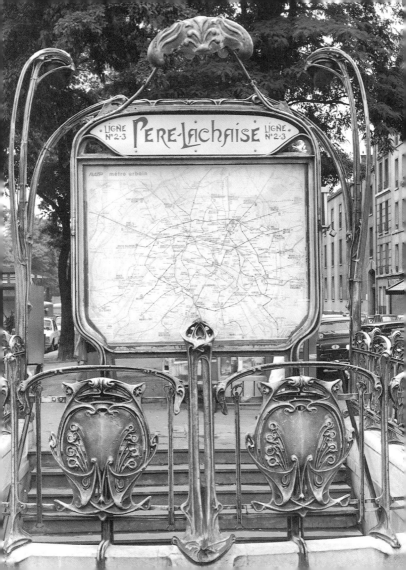

Because of its decorative qualities, Art Nouveau was above all a style for interiors. Far more interiors than buildings were designed, many for display at the numerous exhibitions where artists and artisans showed their work. These featured integrated designs, with walls, furniture, rugs, and light fixtures all designed or chosen by the same person. Light and uncluttered, they contrasted sharply with the dark, crowded rooms of the late Victorian era.

Louis Sullivan applied bands of ornament incorporating curving Art Nouveau lines to the National Farmers' Bank (1908), Owatonna, Minnesota.

To Belgium belongs in all justice the honor of having first devised truly modern formulas for the interior decoration of European dwellings.
—Samuel Bing, "L'Art Nouveau," *The Craftsman,* October 1903

In the stair of the Tassel House (1893), Brussels, Victor Horta provided the archetypical Art Nouveau design, unified by the whiplash curves of painted walls and ceilings, mosaic floors, and iron columns and railings.

Staircases provided wonderful opportunities for Art Nouveau designers to exercise their predilection for swooping curves. Indeed, the stairway was often the centerpiece of an interior. Few buildings housed so monumental a tour-de-force of staircase design as the remodeled interior (1907, René Binet) of the Grands Magasins du Printemps in Paris, unfortunately later destroyed by fire.

Stairs in Brussels houses were of particular note. Located in the center of the building, they rose its full height, usually on slender iron columns based on plant forms, to explode in tangles of tendrils against a stained-glass skylight. In buildings where the staircase rose against an outside wall, as at 24, rue Lionnois (1904, Lucien Weissenburger) in Nancy, the landing often was lighted with a large window, perhaps of stained glass. Hector Guimard lighted the rather tight staircase of Castel Béranger (1899) in Paris with a combination of stained glass and, prefiguring Art Deco, glass block, although in hexagons and curves, not squares.

Whatever the form of the stair—curved or straight—it was apt to be bounded by a delicate wrought-iron railing, formed into the expected Art Nouveau whiplash curves.

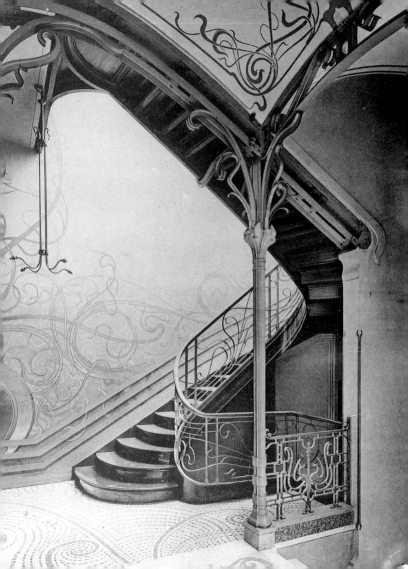

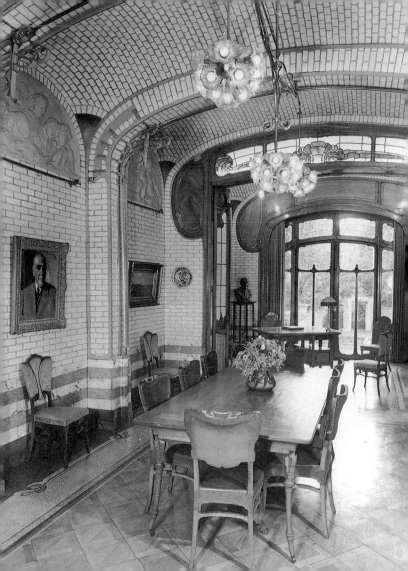

Walls might be sheathed in marble or glazed tile, but most were papered or painted. Victor Horta used English wallpapers in the dining room of the Tassel House (1893) in Brussels, perhaps obtaining them from William Morris or Liberty and Company. The walls of the staircase in the same house, however, were painted in soft shades and then bordered with a painted design of wavy ribbons, interlocking in intricate patterns. A similar treatment of ribbonlike bands sometimes outlined windows and doorways.

Walls also could be left relatively plain, with a painted or papered frieze, or they might be covered entirely by murals. Charles Rennie Mackintosh decorated the walls of Miss Cranston's Buchanan Street Tearoom (1897) in Glasgow with a procession of slender maidens surrounded by cagelike ribbons of Art Nouveau ornament. The dining room of Palais Stoclet (1905–11, Josef Hoffmann) in Brussels, otherwise a rationalist, modernist design, had murals by Gustav Klimt.

Floors might repeat in mosaic or inlaid wood the whiplash designs applied to the walls. Polished wood or parquet floors were left bare or covered with oriental rugs or modern ones in Art Nouveau designs.

In the dining room of Victor Horta's house (1898) in Brussels, walls and the vaulted ceiling are united by a uniform sheathing of glazed brick. Beneath the dining table, a highly polished parquet "rug" is outlined by a mosaic border in whiplash pattern.

The humblest as well as the most exalted ornaments may one day become elements in that revealing whole, the decorative style of an epoch.
—Emile Gallé, 1900

PAINT AND WALLPAPER

Produced by an unknown American manufacturer, this florid poppy-patterned paper was designed by Albert Ainsworth of Hackensack, New Jersey.

English Art Nouveau Wallpaper Patterns

"The Magnolia" (1891, 1990), Jeffrey and Company

"Tokio" (1893, C.F.A. Voysey), Essex and Company

"Artichoke" (1895, Walter Crane), Jeffrey and Company

"Hawkweed" (1902, Lindsay P. Butterfield), Essex and Company

Because English designers pioneered two-dimensional Art Nouveau design, English wallpapers dominated the market. As early as the 1860s William Morris began manufacturing wallpapers whose botanical forms and curvilinear shapes prefigured Art Nouveau. His wallpapers, however, preserved a sense of restraint and decorum that Art Nouveau abandoned. In the early 1880s Arthur Heygate Mackmurdo began to produce designs in several media in which stylized floral motifs were given a flamelike, flickering intensity. Other English designers, such as C.F.A. Voysey and C. R. Ashbee, followed suit. The Belgian artist Henry van de Velde described the impact of Voysey's designs: "as if Spring had come all of a sudden."

Art Nouveau wallpapers were also designed and manufactured in America, but they rarely achieved the quality of the stylish English prototypes.

The Art Nouveau palette for paint and paper generally was springlike indeed—pastel shades of sunny yellows, delicate mauves and pinks, pale greens, and white. However, high-key color combinations—reds, acid greens, hot oranges, and searing blues—were not unknown during the period.

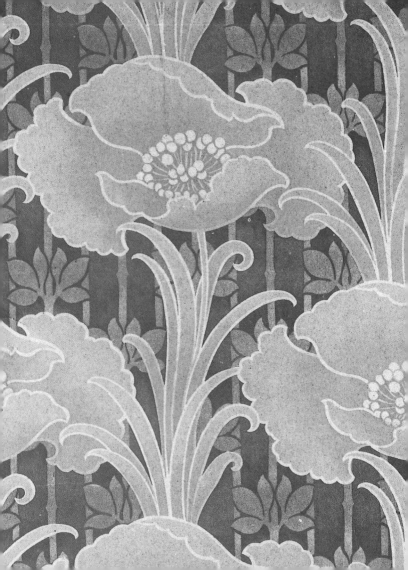

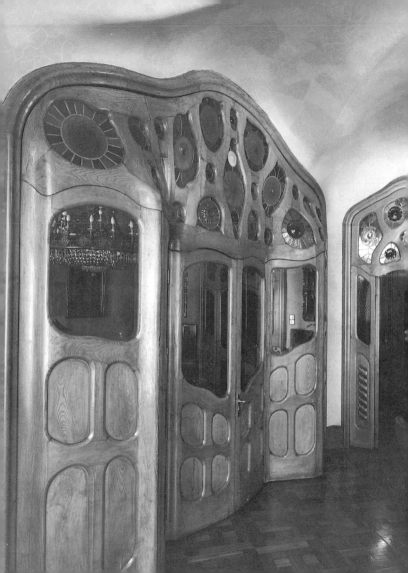

WOODWORK

Although Art Nouveau described itself as modern, it shared with the Arts and Crafts movement an antimachine bias, harking back to the handcraftsmanship of an earlier era. In fact, Art Nouveau's intricate, curvilinear forms were more difficult to achieve with machine tools than the straight-edged lines that came to dominate Arts and Crafts.

Art Nouveau interiors had little standardized woodwork. Moldings followed the contours of irregularly shaped doors and windows or outlined them with the ribbonlike bands similar to ones that sometimes appeared in paint schemes.

Because the aim was totality of design, Art Nouveau interiors often featured built-in furniture, such as cabinets, buffets, and overmantel mirrors and shelving, all fully integrated with the architectural trim. In the Havana Company Cigar Shop (1900, Henry van de Velde) in Berlin, wood elements defined the arches dividing the interior in sections and then swooped downward to form the support for shelving.

In keeping with the preference for light colors in paint and wallpaper, Art Nouveau decorators preferred natural finishes for wood, rather than dark stains or graining.

. . . a return to Divine Nature, always fresh and new in her counsels, can solely and incessantly restore failing imagination.
—Samuel Bing, "L'Art Nouveau," *The Craftsman*, October 1903

Art Nouveau demanded skilled craftsmen—cabinetmakers rather than carpenters—to carve the undulating woodwork of interiors such as Casa Battló (Gaudí, 1906) in Barcelona. Without replicating foliage or blossoms, the design of much Art Nouveau woodwork related to the organic forms of plant life.

METAL AND GLASS

Bright and light, Charles Rennie Mackintosh's doors to the "Room de luxe" in Glasgow's Willow Tearoom (1904) featured slender iron rods, formed into complicated shapes and inset with panels of pale, colored glass.

Art Nouveau adored lightness, attenuation, transparency. . . .
—Nikolaus Pevsner, *The Sources of Modern Architecture and Design*, 1968

Iron and glass were important inside as well as outside. Metal appeared in stair railings as well as in columns that were wrought or cast to take the form of organic stems with brackets resembling the leaves and tendrils of some exotic plant. With the period's attention to every aspect of a building's detailing, even hardware was specially designed, sometimes individually for each building, in the sinuous forms of Art Nouveau.

Glazed screens and doors formed partitions that created a flowing, fluid series of inner spaces. Victor Horta described his interiors for the Solvay House (1898), Brussels, as an "apparent metallic structure and a series of glass screens giving an extended view for evening receptions. . . ." The partitions and skylights drew light into the interior. Other means of providing shimmering light were built-in mirrors; in the 1907 remodeling of Le Printemps in Paris, René Binet installed glass floor tiles with translucent tracery so that light appeared to flow from level to level.

In skylights, metal formed the ribs. Other glazed areas were often divided by metal rods into a series of curvilinear shapes, some of which were filled with stained glass in pastel colors, all to complement the decor.

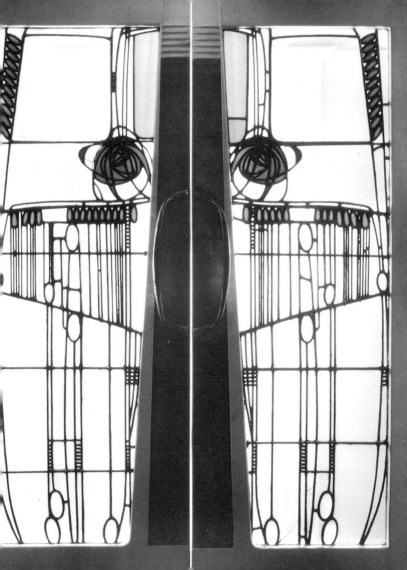

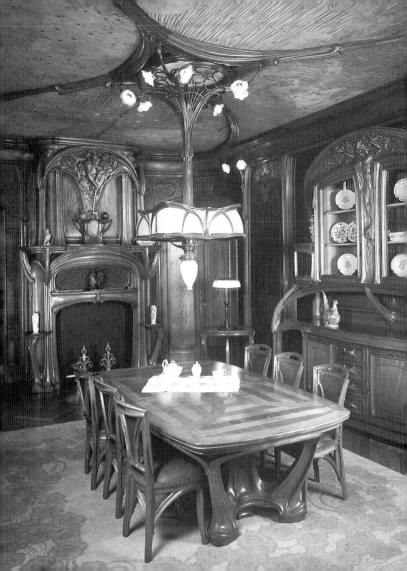

FINISHING TOUCHES

Art Nouveau buildings never were common, but for a brief period home furnishings and decorative objects caught the public's attention — or at least the segment of the public that could afford them. A complete Art Nouveau interior might be too daring for most, but the well-furnished household could be brought up-to-date with Art Nouveau papers on the walls, fabrics at the window, or a Tiffany lamp or Gallé vase on the parlor table.

Eugène Vallin designed this Nancy dining room (1906) in fully integrated Art Nouveau style, carried out in cedar, leather, and glass.

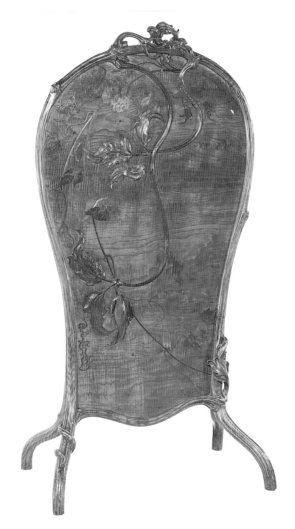

FURNITURE

Most Art Nouveau furniture was custom made. Architect-designers such as Henry van de Velde, Victor Horta, Antoni Gaudí, and Emile André created their own furniture for their buildings. The work of others—such as Bernhard Pankok, Richard Riemerschmid, Tony Selmersheim, Gustave Serrurier-Bovy, and Carlo Bugatti—is known primarily through photographs of furniture for rooms they exhibited at various expositions.

Other designs were too elaborate and depended too much on individual craftsmanship to be produced in quantity. Emile Gallé, famous for his glass, also designed furniture featuring elaborate carving and intricate marquetry, as did Louis Majorelle. Other major cabinetmakers working in Nancy included Eugène Vallin and Jacques Gruber. Among the Paris designers producing wares for Samuel Bing's shop were Georges de Feure, the American-born Edouard Colonna, and Eugène Gaillard. Many of the architects working in the style, such as van de Velde and Hector Guimard, also designed furniture.

Some work, notably by Majorelle and Riemerschmid, was produced in relative quantity, but it never approached the refined detail of individually crafted furniture.

Charles Rohlfs brought Art Nouveau to America with a high-back oak chair (below) produced in 1898. Emile Gallé, better known for his glass, designed a curvaceous fire screen (1900) with refined botanical motifs (opposite).

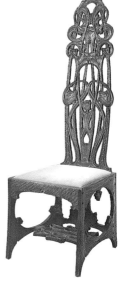

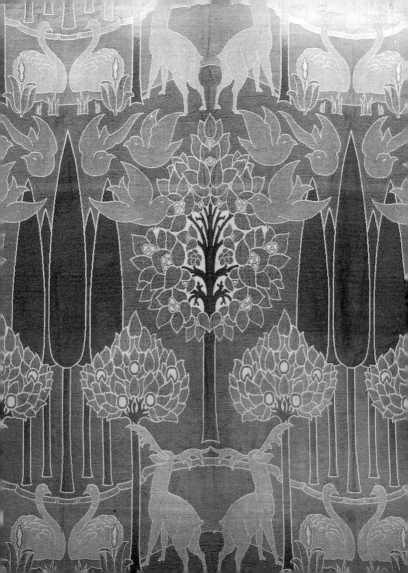

TEXTILES

Art Nouveau textiles fall into two categories: handmade embroideries and tapestries and machine-woven and machine-printed upholstery and curtain fabrics. Laces and rugs, often one-of-a-kind designs, also showed the swirling lines of Art Nouveau.

The sculptor Hermann Obrist introduced Art Nouveau to Germany with a Munich exhibition of embroidery in 1894. *Pan* described one of his works as "frantic movement ... of the sudden violent curves occasioned by the crack of a whip." Obrist's embroideries were intended as wall hangings, but Art Nouveau needlework also decorated clothing, pillows, and tea cozies.

Tapestries were another part of the repertoire. One of the earliest Art Nouveau works is an 1882 tapestry by Arthur Heygate Mackmurdo for the Century Guild. Artists such as Henry van de Velde and Aristide Maillol joined him in designing tapestries.

Nobody, of course, produced more influential Art Nouveau textiles than Liberty and Company of London. Although Liberty never featured the names of its designers, Arthur Silver, Arthur Wilcock, and Lindsay Butterfield were among those responsible for its exuberant botanical images.

Often no single stitch is like any other; an inextricable flickering maze of different stitches invades the ornamental forms, as if animated by a pulse beat or enlivened by organic forces and rhythms like the cells of a living body.
—Georg Fuchs, "Hermann Obrist," *Pan*, 1896

A woolen double cloth (1897, C.F.A. Voysey for Liberty and Company) transformed natural trees, birds, and animals into an abstract pattern of repeated curves.

GLASS AND CERAMICS

In glass as in furniture, Emile Gallé showered his vases with luscious botanical motifs.

Art Nouveau Glass-making Techniques

Cameo glass: Two or more layers of different colors, with a pattern formed by cutting away the upper layer

Pâte-de-Verre: Glass powder of different colors, placed in a mold and fused at high heat, producing an effect like tinted amber

Favrile: Tiffany's patented mixture of several colors, often given an iridescent finish by spraying with metallic vapors

Malleable, capable of being molded, carved or cut, engraved or layered, glass was a perfect vehicle for Art Nouveau.

In France the premier glassworks were in Nancy: that of Emile Gallé, who converted his father's ceramics works to glass production in 1884, and that of the Daum brothers, which opened in 1892. Gallé had been trained as a botanist, and the inspiration of nature is visible in many of his pieces. The Nancy school used a variety of decorating techniques, including cutting through layers of glass to produce various shadings of color.

Despite the lack of an Art Nouveau design community in the United States, an American, Louis Tiffany, was one of the preeminent designers of Art Nouveau glass. After patenting his iridescent favrile glass in 1880, Tiffany used it in the 1890s to create sinuous, elongated Art Nouveau shapes, like his jack-in-the-pulpit vases; peacock feathers were a favorite Tiffany motif.

Ceramists also experimented with new techniques, especially with distinctive glazes. The Rookwood Pottery in Cincinnati and others retained conventional shapes but with delicate, painted decoration incorporating Art Nouveau themes.

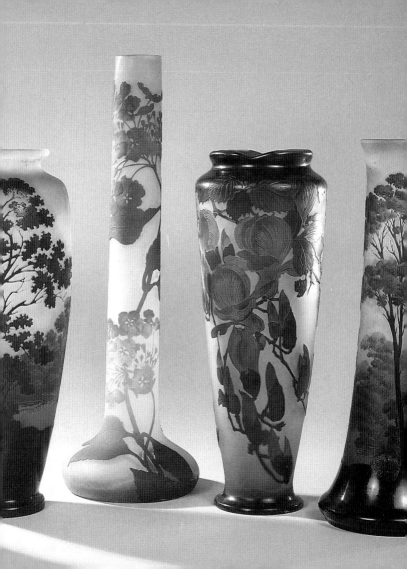

LIGHTING AND LAMPS

Tiffany achieved perhaps his most perfect synthesis of design and light, bronze and glass, in his wisteria lamp, shown here in two sizes.

The introduction of the electric light bulb in 1887 opened dazzling opportunities for Art Nouveau designers. They produced chandeliers like great bouquets—bunches of thin iron or bronze stems exploding into flower. So enamored were they of the light bulb that often the bare bulb was the flower. In other cases the bulb became the pistil, partially or wholly surrounded by petal-like forms in carved crystal or iridescent glass.

Table lamps were made in similar forms, but in these the bulbs often were completely shielded by glass shades. The bases and shafts might be glass or metal; bronze was particularly favored.

Lamps were another area in which Louis Tiffany set the standard. Some were purely abstract, but he also made both a "bouquet" form and other botanical lamps based on a single plant form. Cast bronze formed bases and shafts resembling stems and foliage, while stained-glass shades in brilliant and subtle tones interpreted blossoms. Tiffany had many emulators but no equals.

Despite the infatuation with electric light, candles did not fade out. Particularly attractive candlesticks came from the hands of Henry van de Velde and Georges de Feure.

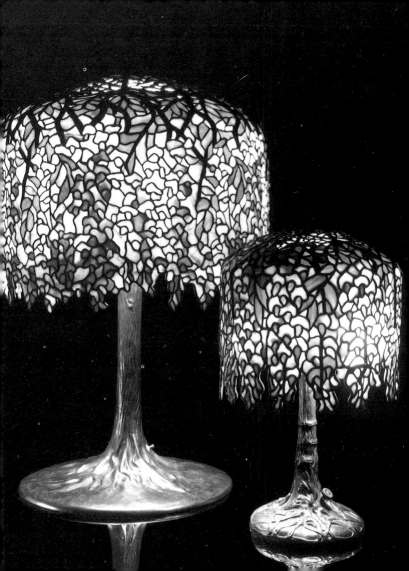

Sculptors of
Bronze Statuettes
Rupert Caradin
Alexandre Charpentier
Eugène Feuillâtre
Charles Korschann
Théodore Rivière

Copper, bronze, pewter, and silver were all worked into decorative and useful Art Nouveau objects, but silver—probably because of its malleability—was especially prized.

Metalwork was another area in which Liberty and Company excelled. The trademark for its silver was Cymric; a less expensive pewter was called Tudric. Of Celtic inspiration, the most elaborate of these were inset with bright enamel plaques or semiprecious stones. In the United States Gorham and Company produced an expensive, entirely handmade line of better than sterling quality, called Martele.

Silversmiths all over the European continent produced one-of-a-kind tea sets, ewers, vases, and desk sets. And no boulevardier was complete without his silver cane handle, often in the form of a serpent or exotic bird. Commercial manufacturers in

This tea and coffee set in pewter and teak (ca. 1904, Joseph Maria Olbrich) combines the geometric forms favored in Austria with the curves of Art Nouveau.

the United States turned out small silver items, particularly toilet articles, such as mirrors and brushes, as well as picture frames.

Bronze and gilded-metal statuettes were popular ornaments. Usually these took the form of nude or lightly clad maidens, nymphs, and mermaids—some forming the bases of lamps and candelabra.

All art is at once surface and symbol.
—Oscar Wilde,
The Picture of Dorian Gray, 1891

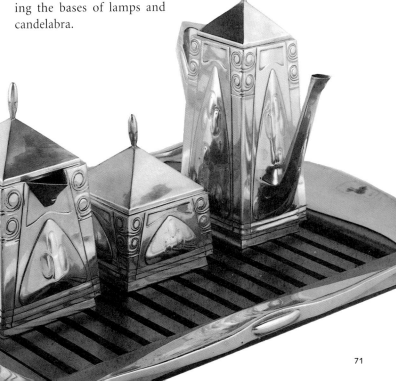

During Art Nouveau's brief flowering, its admirers immersed themselves in the style. They could live in Art Nouveau houses or apartments furnished with Art Nouveau pieces, shop in Art Nouveau stores, dine in Art Nouveau restaurants, sip coffee or a drink in Art Nouveau cafes, and visit exhibitions where Art Nouveau designs were displayed. In Barcelona they could even enjoy an Art Nouveau park and worship in an Art Nouveau church.

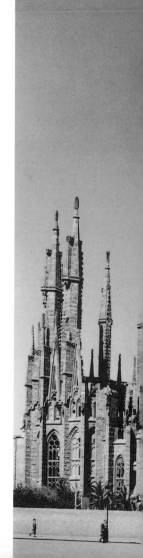

Antoni Gaudí worked on the Sagrada Familia for his entire professional life, from the early 1880s until his death in 1926—creating an Art Nouveau landmark.

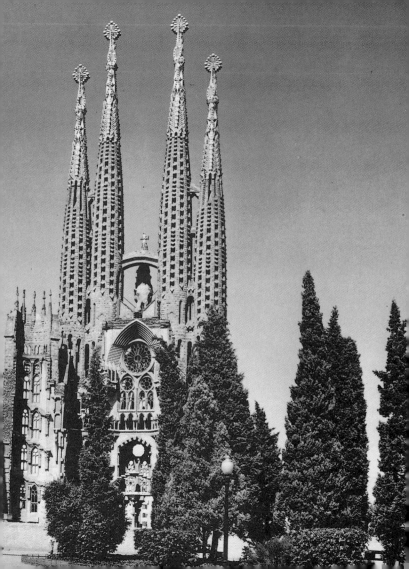

THE ARTISTIC HOUSE

Joseph Olbrich de-
signed this house for
himself (ca. 1899), one
of several in the artists'
colony at Darmstadt.
The Austrian and Ger-
man artists housed there
participated as a group
in expositions at Paris
(1900), Turin (1902),
and St. Louis (1904).

While the style and ornament of Art Nou-
veau houses repudiated the past, their basic
form and placement in relationship to the
street and to one another depended on tra-
dition. In Brussels a deep-seated preference
for private dwellings led to extensive con-
struction of townhouses—some designed
especially for individual clients, others built
on speculation. Prominent among their de-
velopers was the architect Ernest Blérot, who
was responsible for more than one hundred
houses, many in the Saint-Boniface area. Al-
though most Parisians lived in apartments,
townhouses were also built there, such as
those of the chanteuse Yvette Guilbert (1900,
F.-X. Schoellkopf) and the jeweler René
Lalique (c. 1900), a design of his own.

Nancy also had townhouses, but several
of the best examples of that city's Art Nou-
veau architecture are freestanding houses.
Villas and palazzos were built in Italian cities
from Milan and Turin to Florence.

In 1899 the Grand Duke of Hesse founded
an artists' colony at Darmstadt and invited
Joseph Maria Olbrich to design the artists'
houses. These attractive villas (1899–1908)
are in the geometric, Secessionist version of
Art Nouveau associated with Vienna.

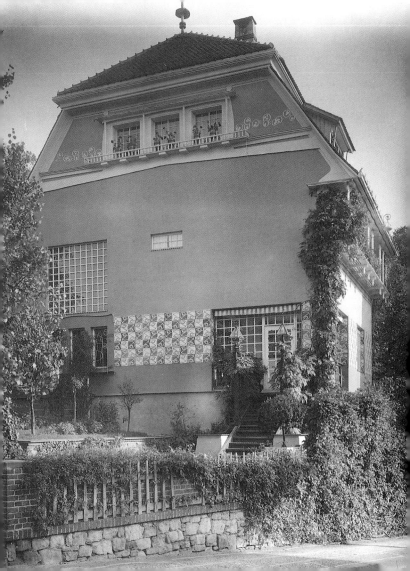

APARTMENTS AND HOTELS

At Casa Battló Antoni Gaudí transformed an existing building in 1906 into one of Art Nouveau's masterpieces. Its undulating facade sparkles in the Barcelona sun, with shifting light reflecting off the disks of pale glass set like gems into the facade.

The man's talent is so dazzling that even the blind would recognize Gaudí's work by touching it.
—Ramiro de Maetzu, "El Arquitecto del Naturalismo," *Nuevo Mundo,* March 16, 1911

Apartment houses have always been associated with Paris, and the first Art Nouveau apartment house—Hector Guimard's Castel Béranger (1899)—also was built there. Guimard had completed its design when he visited Brussels in 1895, but on his return he redesigned the finishes and ornament in the new style. Other notable Paris apartment houses were the work of Jules Aimé Lavirotte; one is now the Céramic Hôtel (1904), so named because of its lavish tile ornament.

Antoni Gaudí's two apartment houses—Casa Battló (1906), a remodeling of an existing building, and Casa Milá (1910)—are among the best known monuments of the style. Otto Wagner's more restrained Vienna apartment buildings at 38–40 Linke Wienzeile (1899) are recognized as Art Nouveau masterpieces. Milan and Turin boast Art Nouveau apartment houses, among them Pietro Fenoglio's Villa Scott (1902) in Turin.

Art Nouveau hotels, similar in scale to apartment buildings, fulfilled patrons' desires for luxury and novelty. Two prominent examples in Prague are the Central Hotel (1902, Běrich Bendelmayer, Dryak and Ohmann) and the Grand Hotel Europa (1907, Bendelmayer).

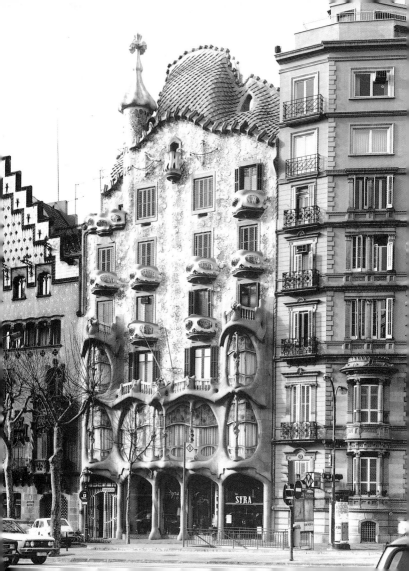

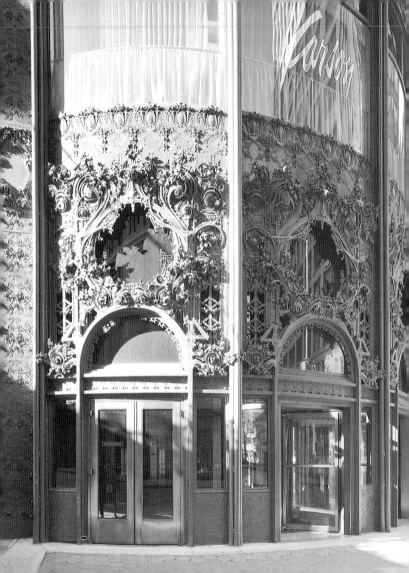

By 1900 general prosperity had created a large middle class with a seemingly insatiable appetite for consumer goods. Industrialization provided products to fulfill the demand. A new building type—the department store—developed in the United States to fit the needs of this mass market.

By the turn of the century department stores appeared in major European cities. One of the first was Le Printemps (1881, Paul Sedillé) in Paris, which did not blossom out in full Art Nouveau grandeur until remodeled by René Binet in 1907. The same year Paris welcomed completion of the first section of La Samaritaine (Frantz Jourdain).

Another early store was Old England in Brussels (1899, Paul Saintenoy), which still survives, although stripped of most of its Art Nouveau decoration. Victor Horta designed several department stores—L'Innovation (1901) and the Grand Bazar Anspach (1903), both in Brussels, and the Grand Bazar Frankfort (1903) in Germany.

While not strictly Art Nouveau, Louis Sullivan's exuberant ornament, particularly for Chicago's Schlesinger and Mayer (later Carson, Pirie, Scott) Department Store (1903), shared a common curvilinear approach.

The Great Shops are now to be reckoned among the sights and curiosities of Paris ... huge bazaars in which everything from old Persian carpets to a packet of pins may be had.
—Paris Exhibition, 1900

Louis Sullivan's intertwined, curving foliate decoration on the entrance to Chicago's Carson, Pirie, Scott Department Store (1903) is the most famous example of Art Nouveau–related ornament in America.

SPECIALTY SHOPS

Henry van de Velde designed every aspect of the lost Havana Company Cigar Shop (1900), Berlin—the swooping arches, the shelving, the furniture, and the whiplash motifs of the painted frieze.

Lost Art Nouveau Shops

Atelier Elvira (1898, August Endell), Munich

Apollo Candle Shop (1900, Josef Hoffmann), Vienna

Fouquet Jewelers (ca. 1900, Alphonse Mucha), Paris

Haby's Barber Shop (1901, Henry van de Velde), Berlin

Specialty shops were important in promoting Art Nouveau. When Samuel Bing opened La Maison de l'Art Nouveau in Paris in 1895, the facade was hung with canvases by the English artist Sir Frank Brangwyn, who also designed stained-glass windows for Louis Tiffany. Bing's opening display featured a room by Henry van de Velde, Tiffany glass, and stained glass designed by artists such as Pierre Bonnard and Edouard Vuillard. The art critic Julius Meier-Graefe opened Maison Moderne in 1899. Other shops indicated their specialization in the new style by including the word *modern* or *moderne* in their names.

In addition to their contents, shop fronts themselves helped establish Art Nouveau's international reputation. Stores were built in the great centers of Art Nouveau as well as in other large and small cities, including some in the United States.

The whims of fashion have not been kind to these shops. Many of the most famous are gone. A few notable ones remain, like the Brussels store of the shirtmaker Niguet (1899, Paul Hankar). Other examples survive in the Art Nouveau centers and in smaller cities such as The Hague, Ghent, and Lille.

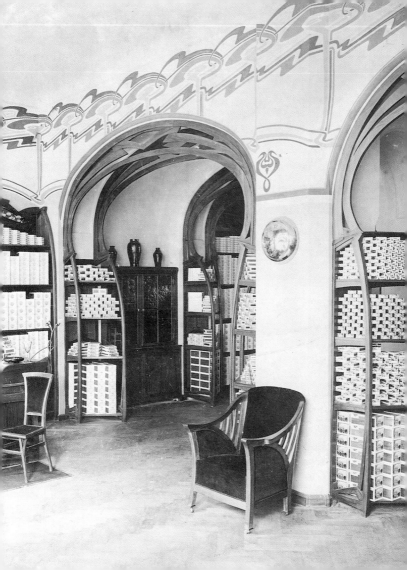

[The 1900 Paris Exposition is] a gathering of the very best the 19th century has to offer in natural and manufactured products and in examples of the liberal arts.

—Max Maury, *Paris and the Exposition,* 1900

International exhibitions and trade fairs set the tone for the era. In England the Arts and Crafts Exhibition Society sponsored shows in the late 1880s that included some Art Nouveau designs. By the mid-1890s the Brussels painters and sculptors known first as Les XX and later as La Libre Esthetique showed work by Aubrey Beardsley and Jan Toorop and an interior by Gustave Serrurier-Bovy.

The Vienna Secession organized an exhibition in 1898, although the Vienna designers already were departing from Art Nouveau. The main hall, Secession House (Joseph Maria Olbrich), was symmetrical and recti-

Victor Horta's proposed design for a Congo Pavilion for the Paris Exposition of 1900 was based on an organic metal structure and curving glass roofs.

linear, but the decoration of the entrance and the openwork dome composed of leaves were to the Art Nouveau taste.

The greatest showcase for Art Nouveau was the Exposition Universelle in Paris in 1900. René Binet's entrance pavilion, with its exposed iron structure, owed something to the 1889 Eiffel Tower but also featured decorative, brightly colored ceramic cabochons. Most of the established and aspiring Art Nouveau designers exhibited here. Samuel Bing's pavilion featured rooms by his chief designers, while other rooms were by Louis Majorelle, Richard Riemerschmid, and Bernhard Pankok.

Nouveau Expositions

Les XX, Brussels,
 1891–93

Liège, 1895

Dresden, 1897

Düsseldorf, 1902

Turin, 1902

Nancy, 1909

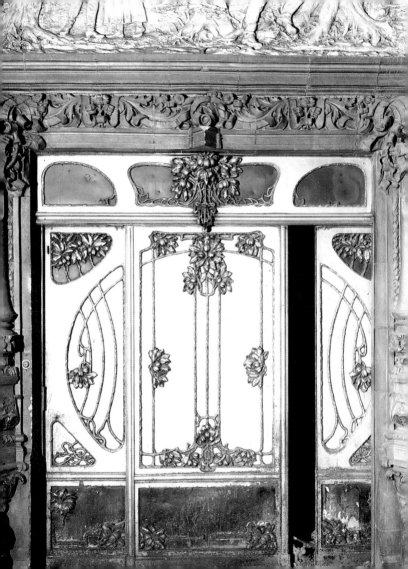

Newer forms of entertainment—the cabaret and music hall—enticed many, but conventional theater and opera remained popular. The repertoire, however, was enlarged. Maurice Ravel and Claude Debussy, inspired by symbolist authors such as Stéphane Mallarmé and Maurice Maeterlinck, developed shimmering, impressionistic music. Operetta and ragtime became popular, while plays by Anton Chekhov, George Bernard Shaw, and Oscar Wilde enriched the theater.

Because numerous theaters and concert halls had been constructed in the previous half century, few were built in the Art Nouveau style; fewer have survived. Victor Horta's Maison du Peuple (1899), which incorporated a large auditorium, and Hector Guimard's Humbert de Romans concert hall (1901) have been destroyed. One of the rare survivors is Lluis Domenech's idiosyncratic Palau de la Musica Catalana (1908) in Barcelona.

No American theaters were consistently Art Nouveau in style, but many incorporated Art Nouveau motifs in their interiors. One of the most lavish was New York's New Amsterdam Theater (1903, Herts and Tallant), later converted to show movies.

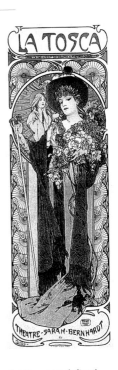

Art Nouveau defined Alphonse Mucha's poster for Sarah Bernhardt's *Tosca* (above) and the New Amsterdam Theater's iron-and-glass doors (opposite).

The gaiety of *fin de siècle* Paris still glitters at Maxim's (1900, Louis Marnez), where mirrors, metal, and electric light combine to create a shimmering, romantic atmosphere.

Surviving Cafes in the Nouveau Style

Café Américain, Moulins

Café at the Hotel
 Métropole, Brussels

Café des Beaux-Arts,
 Armentières

Restaurant Julien, Paris

For the affluent European middle class, dining out or meeting friends at a cafe had become one of life's pleasures by the turn of the century. Art Nouveau, with its lightness and air of gaiety, was well suited to making such experiences enjoyable.

Occasionally a restaurant was a totally Art Nouveau design—for example, the main restaurant at the 1900 Paris Exposition, the Pavillon Bleu (E.A.R. Dulong). Its many-tiered side and rear facades rose like an Art Nouveau wedding cake, and its interiors, by Dulong and Gustave Serrurier-Bovy, were pure examples of the style. More often only the interior was the work of an Art Nouveau architect or designer. In ideal cases, such as Charles Rennie Mackintosh's Glasgow tea-rooms, every part of the decor was designed by the same person—wall decorations, furniture, lighting fixtures, and even the china and cutlery.

Many Art Nouveau restaurants and cafes have disappeared. Dining in Art Nouveau style, however, is still possible at the Café-restaurant, 17–19, rue Henri Maus, Brussels, and the dining room of the Hôtel-Brasserie Excelsior (1910, Lucien Weissenburger; decor by Louis Majorelle) in Nancy.

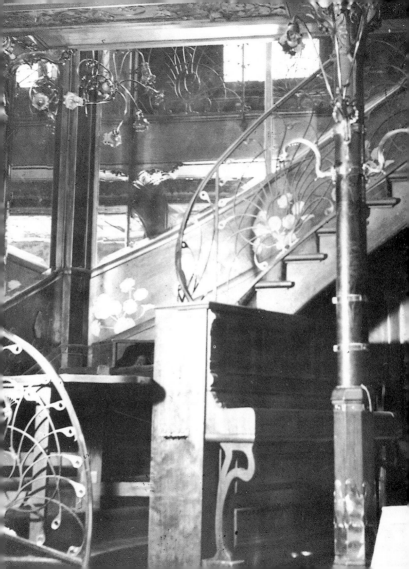

TRANSPORTATION

Will Bradley's poster (above), like others of the era, implied that bicycles were suitable vehicles for women.

Many of Otto Wagner's stations for the Vienna Stadtbahn (1900) (opposite) incorporated Art Nouveau motifs, although in the cooler, more rationalist mode favored in Austria.

The revolution in transportation that began in the early nineteenth century with the development of railroads continued rapidly into the new century. By 1890 commercial automobile production had begun in Germany. In 1903 the Wright brothers made their first flight. Functional requirements, not style, dictated the design of early cars and planes. Carlo Bugatti, known for his Art Deco cars, began as a designer of Art Nouveau furniture.

But automobiles and airplanes were rare toys for the rich. What gave the masses greater mobility were bicycles and intra-urban railway systems. The bicycle, with its curved handlebars and swooping line from high front wheel to pedals, was the perfect vehicle for Art Nouveau representation and appeared on numerous posters.

The first subway system—London's—opened in 1884. Hector Guimard's iron-and-glass stations, pavilions, and ticket offices for the Paris Métro, which opened in 1900, embodied sensuous botanical forms and have become icons of the Art Nouveau style.

IN STYLE

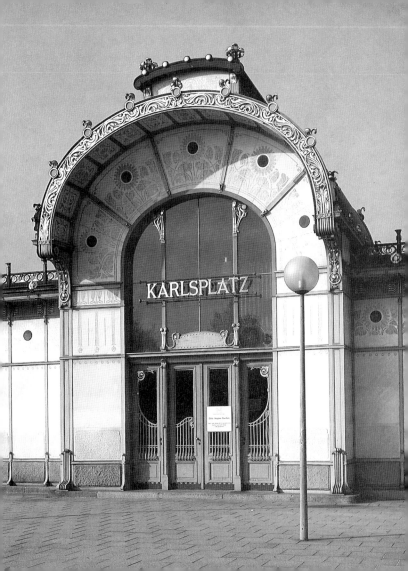

MUSEUM COLLECTIONS

Anderson Collection
University of East Anglia
Sainsbury Centre for
Visual Arts
Norwich NR4 7TJ,
England

Cooper-Hewitt Museum
Smithsonian Institution
2 East 91st Street
New York, N.Y. 10028

Horta Museum
25, rue Américaine
Saint-Gilles
1060 Brussels, Belgium

**Karl-Ernst-Osthaus
Museum**
Hoch Strasse 73
58095 Hagen, Germany

**Metropolitan
Museum of Art**
Fifth Avenue and
82nd Street
New York, N.Y. 10028

**Musée des Arts
Décoratifs**
Palais du Louvre
107–109, rue de Rivoli
75001 Paris, France

**Musée de l'Ecole
de Nancy**
36–38, rue du
Sergent-Blandan
54000 Nancy, France

**Museum of Arts
and Crafts**
Steintorplatz
20099 Hamburg,
Germany

Museum of Modern Art
11 West 53d Street
New York, N.Y. 10019

**Österreichische
Nationalbibliothek**
Heldenplatz
Corps de logis der Neuen
Hoffburg
A-1015 Vienna, Austria

**Nordenfjeldske
Kunstindustrimuseum**
Munkegata 5
7013 Trondheim,
Norway

**Victoria and Albert
Museum**
Exhibition and Cromwell
Roads
South Kensington
London SW7 2RL,
England

**Virginia Museum
of Fine Arts**
2800 Grove Avenue
Richmond, Va. 23221

William Morris Gallery
Lloyd Park
Forest Road
London, E17 4PP,
England

ADDITIONAL SITES TO VISIT

*See additional places
cited in the text.*

**Carson, Pirie, Scott
Department Store** (1903)
Chicago, Ill.

Casa Battló (1906)
Barcelona, Spain

Casa Milá (1910)
Barcelona, Spain

Castel Béranger (1899)
Paris, France

Chez Maxim's (1899)
Paris, France

**Grands Magasins de la
Samaritaine** (1891–1914)
Paris, France

**Grands Magasins du
Printemps** (1907)
Paris, France

Grosses Glückert House
(1900)
Darmstadt, Germany

Hankar House (1893)
Brussels, Belgium

Horta Museum (1898)
Brussels, Belgium

**Karl-Ernst-Osthaus
Museum (interior)**
(1902)
Hagen, Germany

**Karlsplatz Stadtbahn
Station** (1900)
Vienna, Austria

Maison Coilliot (1900)
Lille, France

Majolica House (1898)
Vienna, Austria

Métro (1900–13)
Paris, France

**92, bis quai Claude-
le-Lorrain** (1903)
Nancy, France

**Old England Depart-
ment Store** (1899)
Brussels, Belgium

Park Güell (1914)
Barcelona, Spain

Sagrada Familia (1883–)
Barcelona, Spain

Secession House (1898)
Vienna, Austria

Solvay House (1898)
Brussels, Belgium

3, square Rapp (1899)
Paris, France

Villa Ruggeri (1907)
Pesaro, Italy

Villa Scott (1902)
Turin, Italy

RECOMMENDED READING

Amaya, Mario. *Art Nouveau*. 1966. Reprint. New York: Schocken Books, 1986.

Barilli, Renato. *Art Nouveau*. London and New York: Paul Hamlyn, 1969.

Battersby, Martin. *Art Nouveau*. London and New York: Paul Hamlyn, 1969.

Bouillon, Jean-Paul. *Art Nouveau, 1870–1914*. New York: Rizzoli, 1985.

Costantino, Maria. *Art Nouveau*. Greenwich, Conn.: Brompton Books, 1989.

Duncan, Alastair. *Art Nouveau*. London and New York: Thames and Hudson, 1994.

Hardy, William. *A Guide to Art Nouveau Style*. Secaucus, N.J.: Chartwell Books, 1986.

Haslam, Malcolm. *In the Nouveau Style*. New York: Little Brown, 1989.

Hitchcock, Henry-Russell. *Architecture: Nineteenth and Twentieth Centuries*. 1958. 4th ed. Reprint. New York: Penguin, 1977.

Pevsner, Nikolaus. *The Sources of Modern Architecture and Design*. 1968. Reprint. London and New York: Thames and Hudson, 1989.

Rheims, Maurice. *The Flowering of Art Nouveau*. Trans. by Patrick Evans. New York: Abrams, 1966.

Russell, Frank, ed. *Art Nouveau Architecture*. New York: Rizzoli, 1979.

Schmutzler, Robert. *Art Nouveau*. 1962. Reprint. New York: Abrams, 1978.

Selz, Peter Howard, Mildred Constantine, et al. *Art Nouveau: Art and Design at the Turn of the Century*. New York: Museum of Modern Art, 1959. Reprint. New York: Arno Press, 1972.

Sterner, Gabriele. *Art Nouveau: An Art of Transition—From Individualism to Mass Society*. Trans. by Frederick G. and Diana S. Peters. Woodbury, N.Y.: Barron's, 1982.

Waddell, Roberta, ed. *The Art Nouveau Style*. New York: Dover, 1977.

INDEX

CREDITS

© Wayne Andrews/Esto: 47, 72–73

Archives d'Architecture Moderne: 43, 44, 51, 52

Art Institute of Chicago, photographs © 1994. All Rights Reserved: 4–5 (oil on canvas, 1893–95, 123 x 141 cm, Helen Birch Bartlett Memorial Collection, 1928.610); 19 (lithograph, 1893, 120.8 x 88.5 cm, Mr. and Mrs. Carter H. Harrison Collection, 1949.1004)

Art Nouveau Architecture, Frank Russell, ed. (London: Academy Editions, 1979): 32–33, 82–83

Bettmann Archive: 11, 16, 34

Bibliothèque Nationale de France: 18, 85

Bildarchiv Foto Marburg/Art Resource, New York: 28–29, 75, 81

William Brumfield: 27, 40

Charles Hosmer Morse Museum of American Art, Winter Park, Fla.: 69

Christie's Images, London: 22, 67

Cooper-Hewitt, National Design Museum, Smithsonian Institution/Art Resource, New York: 55

Courtauld Institute of Art: 15

Whitney Cox: 84

Freer Gallery of Art, Smithsonian Institution, Washington, D.C.: 35 (04.61: "Harmony in Blue and Gold: The Peacock Room." Oil paint and metal leaf on canvas, leather, and wood: 425.8 x 1010.9 x 608.3 cm. After restoration)

Historic American Buildings Survey: 46

© Angelo Hornak Library: 38–39, 89

Library of Congress: 20, 21, 88

Ralph Lieberman: 56, 77

Minders Photo Studio, Genk, Belgium, from *Art Nouveau: Art and Design at the Turn of the Century* (Museum of Modern Art, 1960), courtesy National Gallery of Art: 24–25

© Munch Museum/Munch-Ellingsen Group/ARS, New York: 17

Musée de l'École de Nancy: 60–61

Musée des Arts Décoratifs: 1

Museum of Modern Art, New York: 2 (van Eetvelde House, 4 Avenue Palmerson, Brussels. 1895. Salon)

Nordenfjeldske Kunstindustrimuseum: endpapers

Norwest Corporation: 48–49

Princeton University, Art Museum: 63 (Gift of Roland Rohlfs, son of Charles Rohlfs)

Reuters/Bettmann: 10

Roger-Viollet: 8–9, 87

© Royal Commission on the Ancient and Historical Monuments of Scotland: 59

Salomé (Wilde, 1893): 31

© 1991 Sotheby's, Inc.: 14

Bob Thall, photographer: 78

University of East Anglia, Norwich, Anderson Collection: 30

Victoria and Albert Museum: 62, 64

Virginia Museum of Fine Arts, Richmond, Va.: 70–71 (Gift of Sydney and Frances Lewis)

Endpapers: A Liberty fabric design (ca. 1895, possibly the Silver Studio).

Page 1: A copper and enamel Art Nouveau pendant (ca. 1900, Samuel Bing).

Page 2: Stairhall of the van Eetvelde House (1895, Victor Horta), Brussels.

Pages 4–5: *At the Moulin Rouge* (1895, Henri de Toulouse-Lautrec).

Produced by Archetype Press, Inc.
Project Director:
Diane Maddex
Editor:
Gretchen Smith Mui
Editorial Assistant:
Kristi Flis
Art Director:
Robert L. Wiser

10 9 8 7 6 5 4 3 2 1

Other titles in the Abbeville StyleBooks™ series include *Art Deco* (ISBN 1-55859-824-3); *Arts & Crafts* (ISBN 0-7892-0010-4) *Early Victorian* (ISBN 0-7892-0011-2); *Gothic Revival* (ISBN 1-55859-823-5); and *Renaissance* (ISBN 0-7892-0023-6).

Library of Congress Cataloging-in-Publication Data
Greiff, Constance M.
Art nouveau / Constance M. Greiff.
 p. cm. — (Abbeville stylebooks)
Includes bibliographical references and index.
ISBN 0-7892-0024-4
1. Art nouveau. 2. Art, Modern—19th century.
I. Title. II. Series.
N6465.A7G74 1995 95–15025
745.4′441—dc20 CIP